10/09

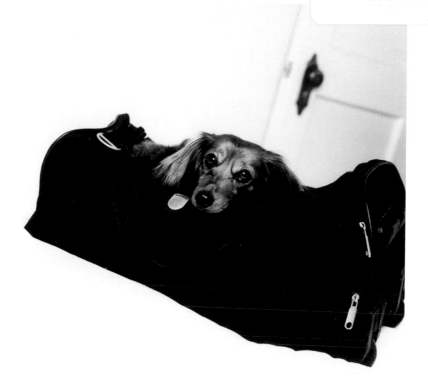

Dachshunds *Short and Long*

Photographs by Amanda Jones

BERKLEY BOOKS, NEW YORK

THE BERKLEY PUBLISHING GROUP
Published by the Penguin Group
Penguin Group (USA) Inc.
375 Hudson Street, New York, New York 10014, USA
Penguin Group (Canada), 90 Eglinton Avenue East, Suite 700, Toronto, Ontario M4P 2Y3, Canada
(a division of Pearson Penguin Canada Inc.)
Penguin Books Ltd., 80 Strand, London WC2R 0RL, England
Penguin Group Ireland, 25 St. Stephen's Green, Dublin 2, Ireland (a division of Penguin Books Ltd.)
Penguin Group (Australia), 250 Camberwell Road, Camberwell, Victoria 3124, Australia
(a division of Pearson Australia Group Pty. Ltd.)
Penguin Books India Pvt. Ltd., 11 Community Centre, Panchsheel Park, New Delhi—110 017, India
Penguin Group (NZ), 67 Apollo Drive, Rosedale, North Shore 0632, New Zealand
(a division of Pearson New Zealand Ltd.)
Penguin Books (South Africa) (Pty.) Ltd., 24 Sturdee Avenue, Rosebank, Johannesburg 2196, South Africa

Penguin Books Ltd., Registered Offices: 80 Strand, London WC2R 0RL, England

The publisher does not have any control over and does not assume any responsibility
for author or third-party websites or their content.

PRINTING HISTORY
Berkley hardcover edition / October 2005
Berkley trade paperback edition / October 2009

Berkley trade paperback ISBN: 978-0-425-23279-8

The Library of Congress has catalogued the Berkley hardcover edition as follows:

Jones, Amanda.
Dachshunds short and long / photographs by Amanda Jones.
p. cm.
ISBN 978-0-425-20709-3
1. Dachshunds—Pictorial works. 2. Photography of dogs. I. Title.

SF429.D25J66 2005

636.753′8—dc22 2005048215

PRINTED IN THE UNITED STATES OF AMERICA

10 9 8 7 6 5 4 3 2 1

For Popeye,
the one who stole my heart.

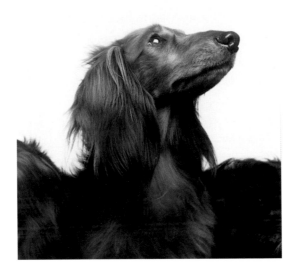

Acknowledgments

I would like to thank Allison McCabe for giving me the opportunity to work on a book dedicated to my favorite breed, and for being such an enthusiastic dog person and dedicated business partner.

Thanks to the Dachshund models and owners who spent their time and energy shooting this book. You were all wonderful!

Andrea Arden: Without your help, the cover shoot might not have gone so well! Your introductions to myriad New York Dachshunds were invaluable. Thank you.

As always, to Chris and Sophie who give me this fantastic opportunity, I love you.

Most kinds of dogs seem to either
Have shapes or proportions all wrong;
They're only one way or the other,
But dachshunds are both short and long.

—Excerpt from the "Dachs Song" is used with permission of Paul DeVries & Murray Weinstock, Dachsong.com

Man who buys Pekingese
requires great status.
Man who buys dachshund
acquires great status.

—CONFUCIUS

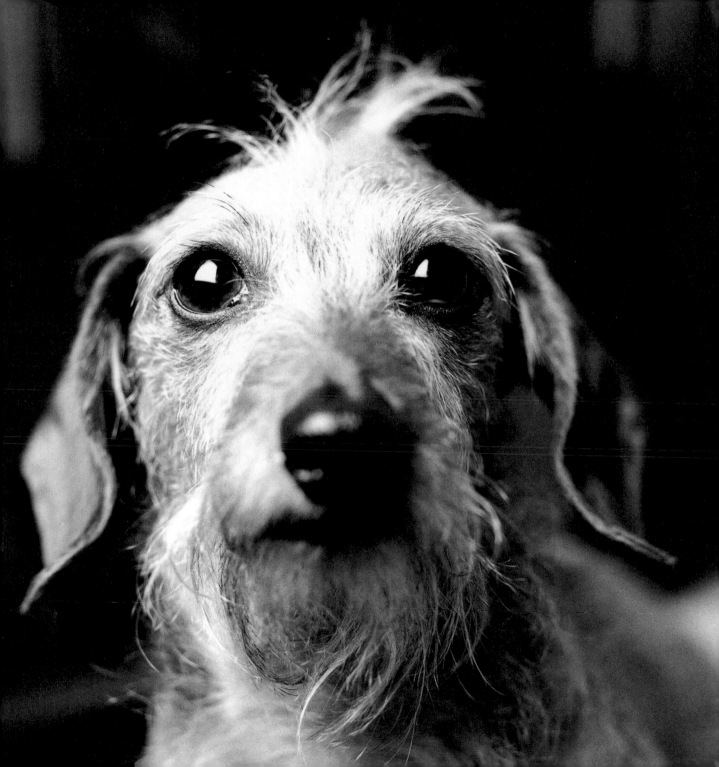

It's easy to get dachs-addicted.

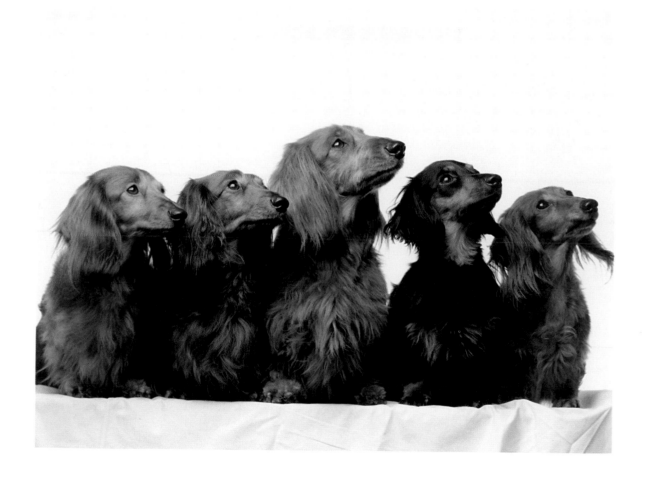

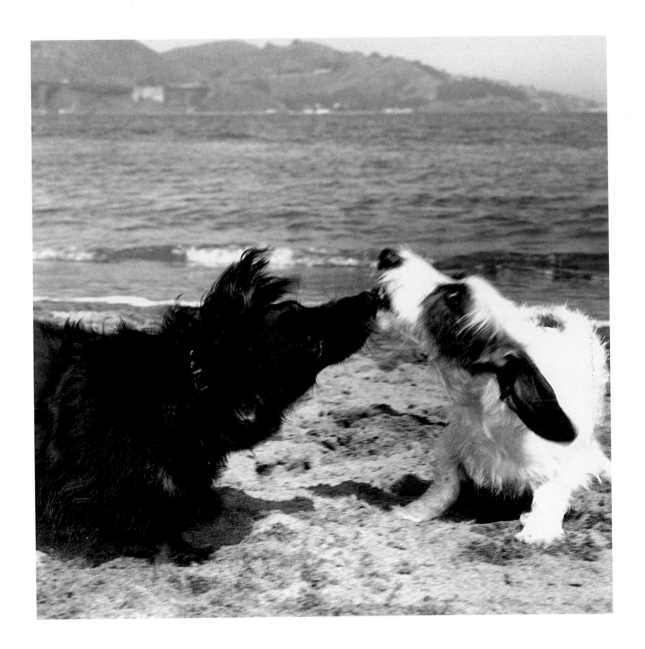

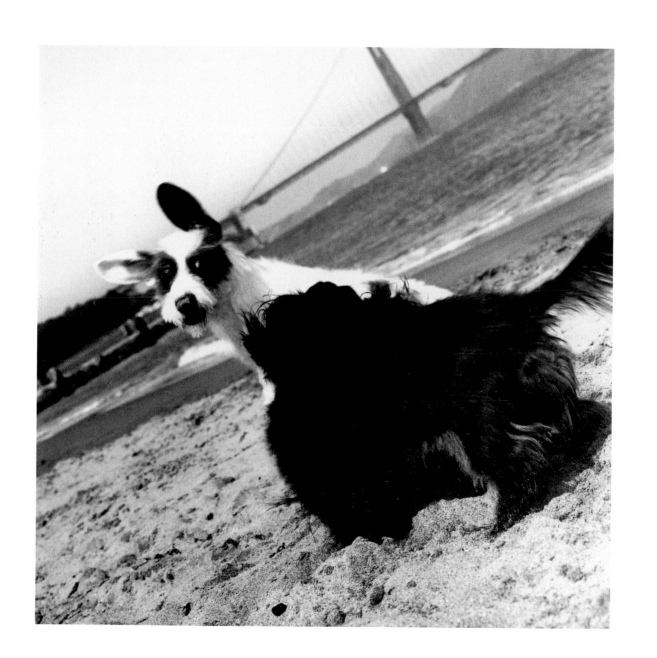

Sleeping on your bed—
there's nothing better.
Unless, maybe, sleeping
wrapped in your sweater.

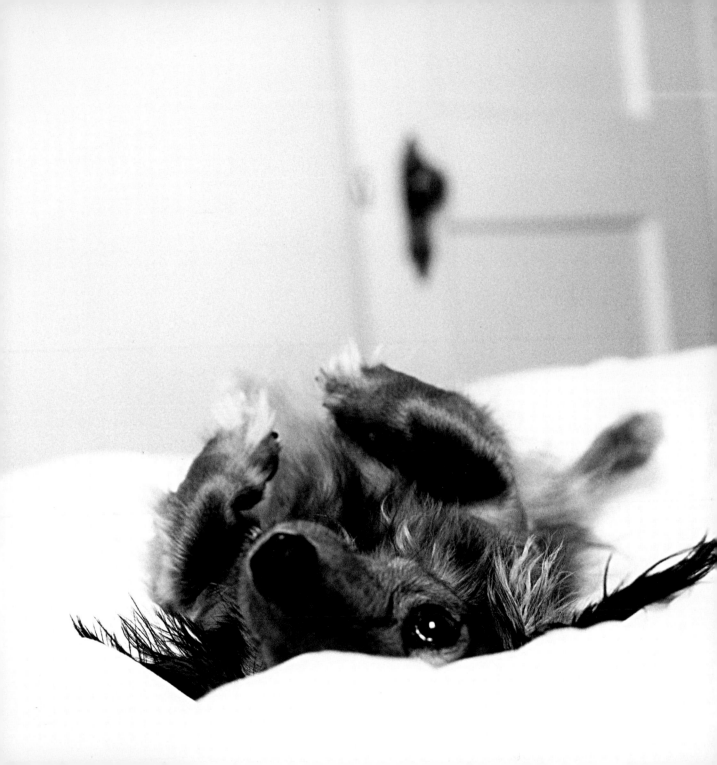

Only *one* treat?

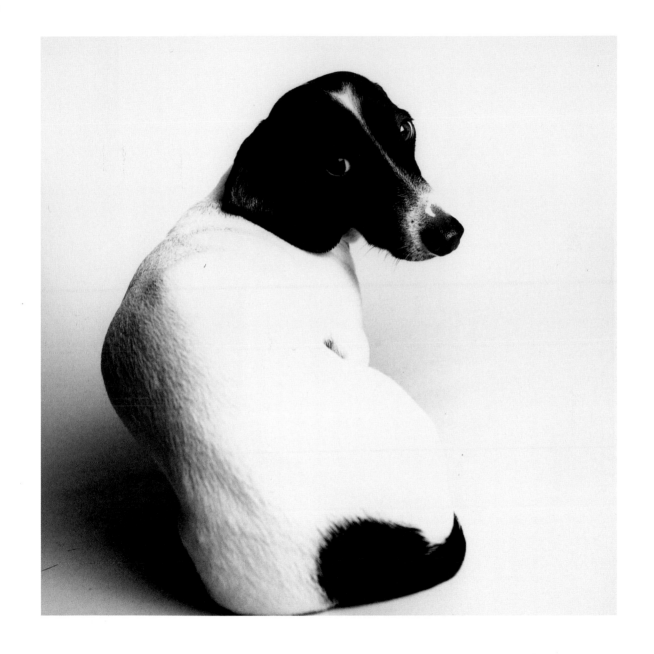

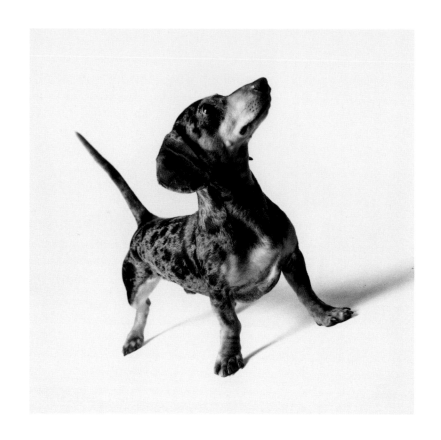

Exclamation tail!

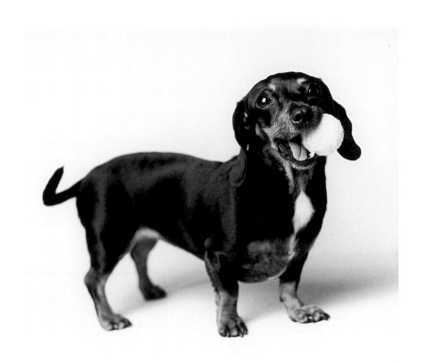

Question-mark tail?

Wake me up as soon as you have the dachshund housetrained.

—Rip Van Winkle

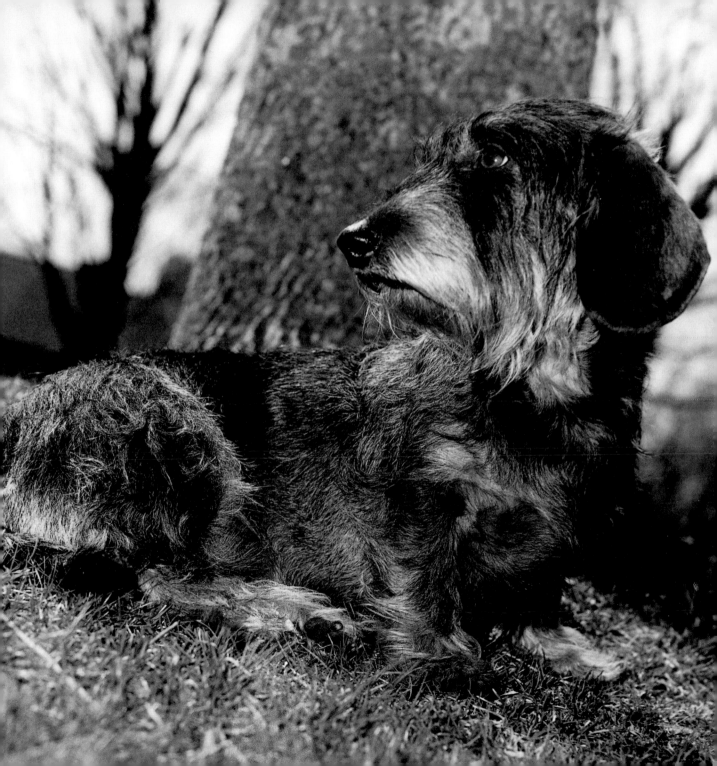

Dachshunds are both short
and long . . .
And waterproof!

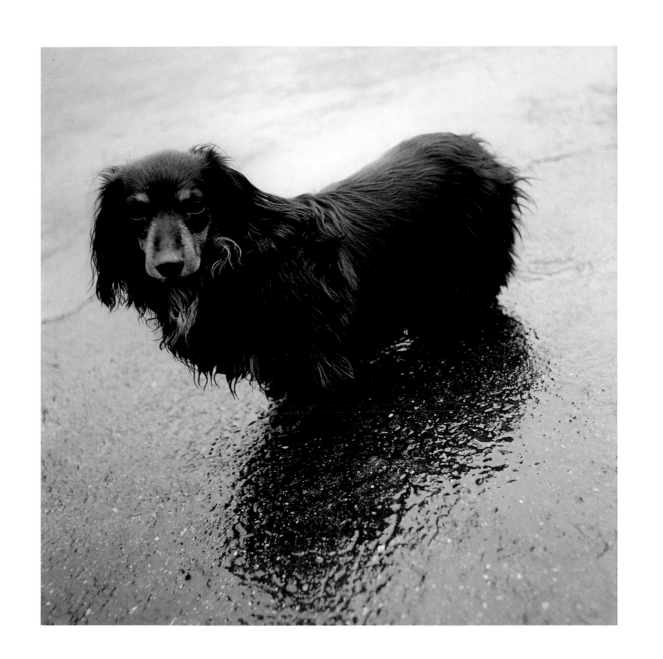

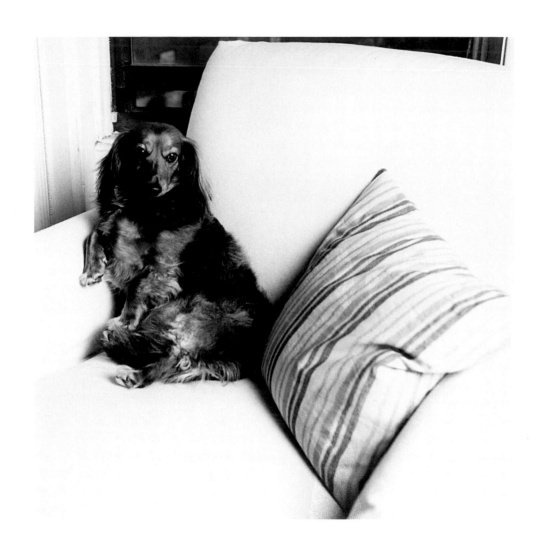

Sure, I'll pose the way you want me to…

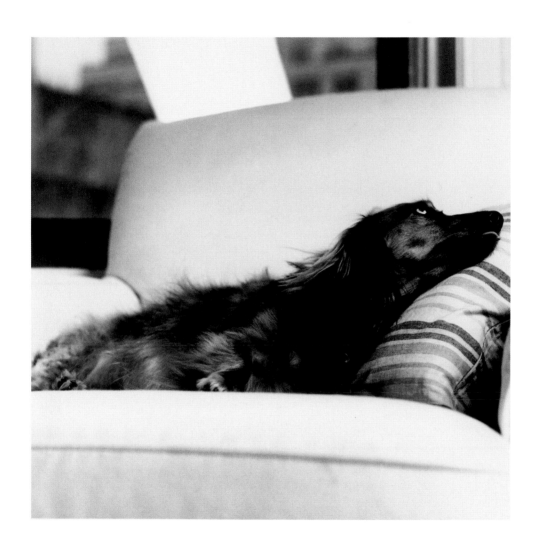

…but not for long.

Those little legs can move!

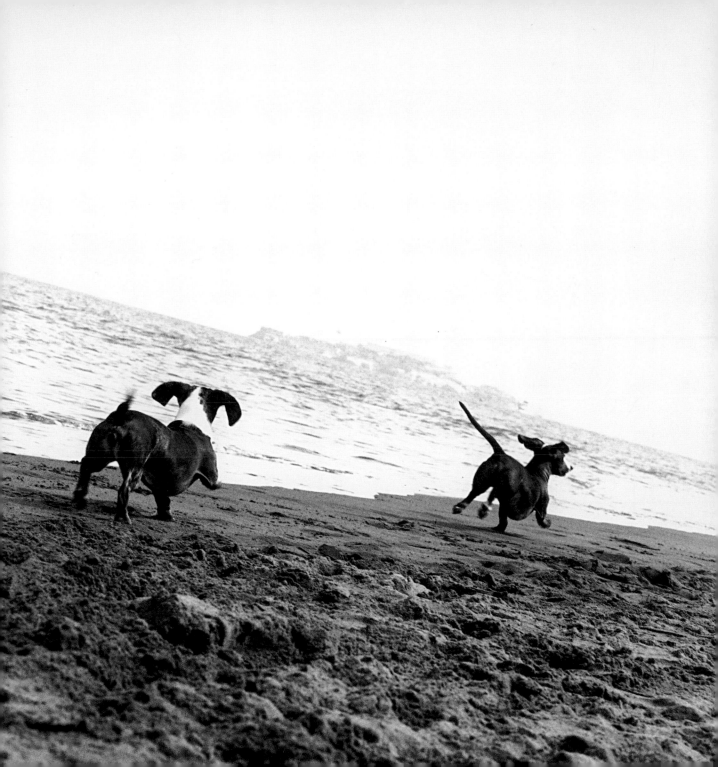

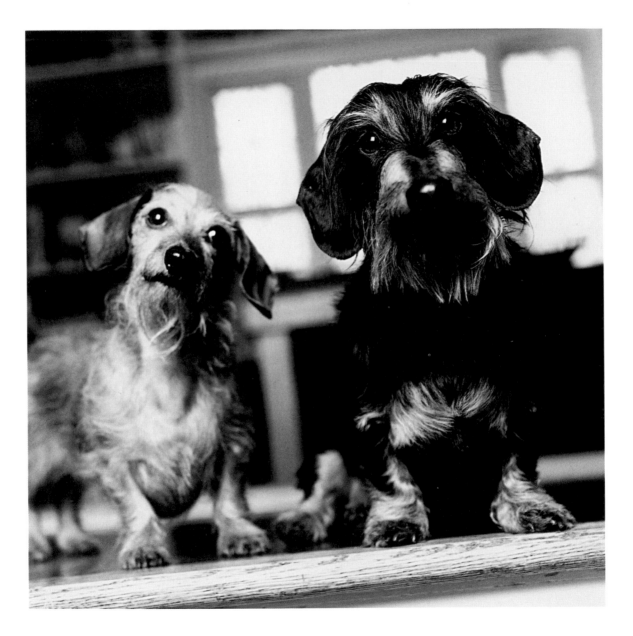

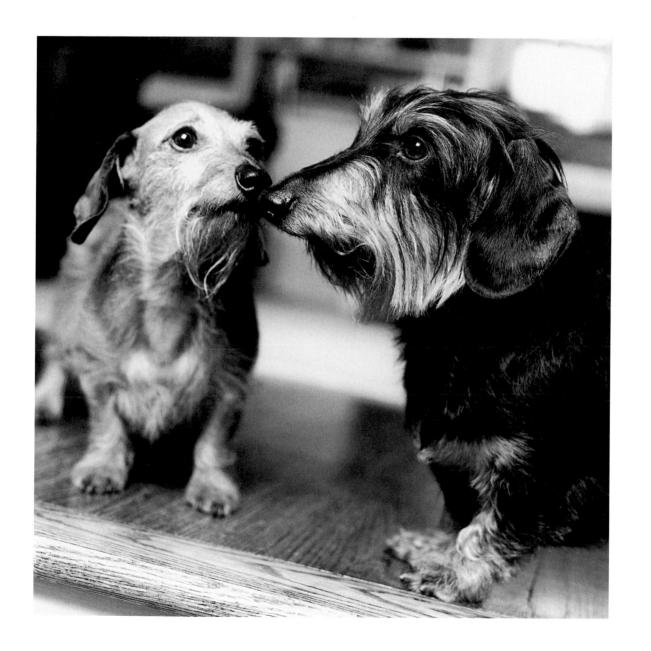

The Look

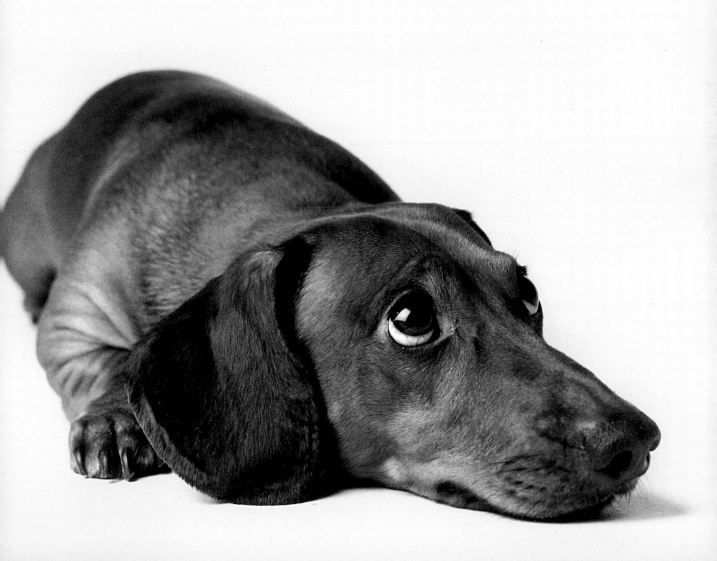

Is that you calling me?
I'm not sure I can hear you.
This wind has given me
a strange ear-do.

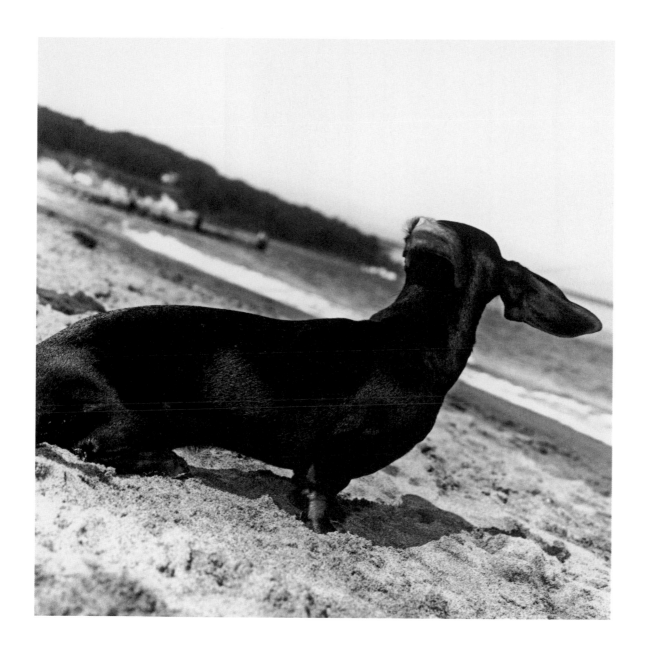

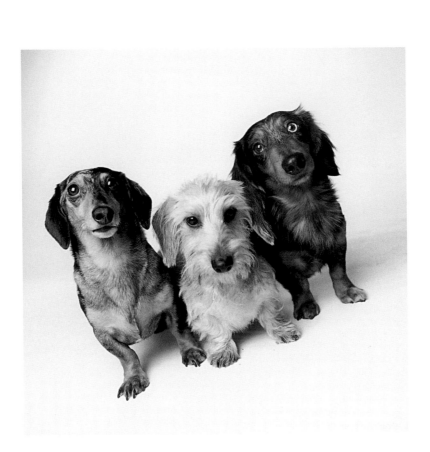

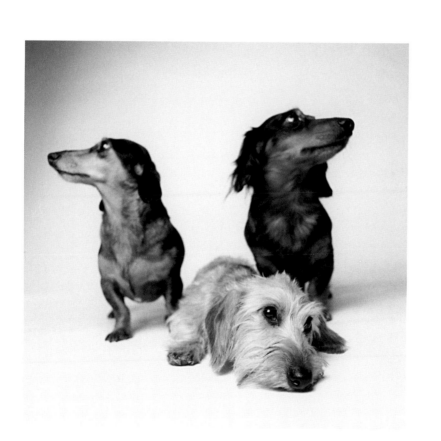

That chewed-up shoe?
I did it.

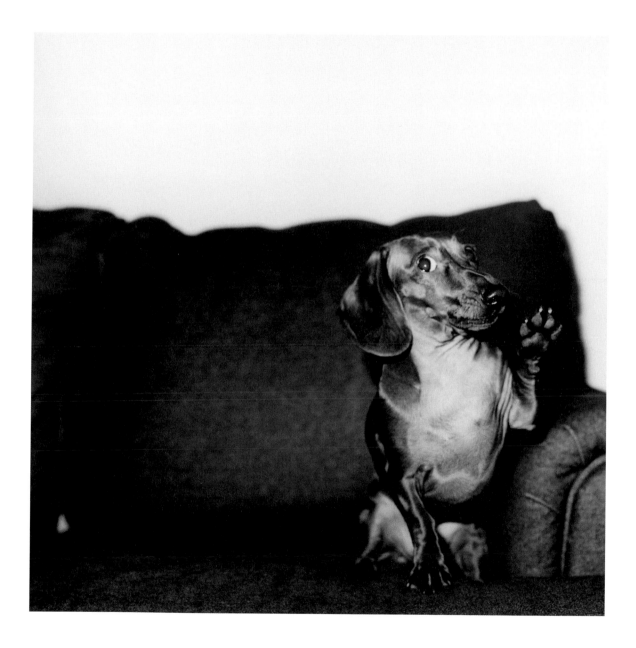

We can smell the cookies!
We know you have them!

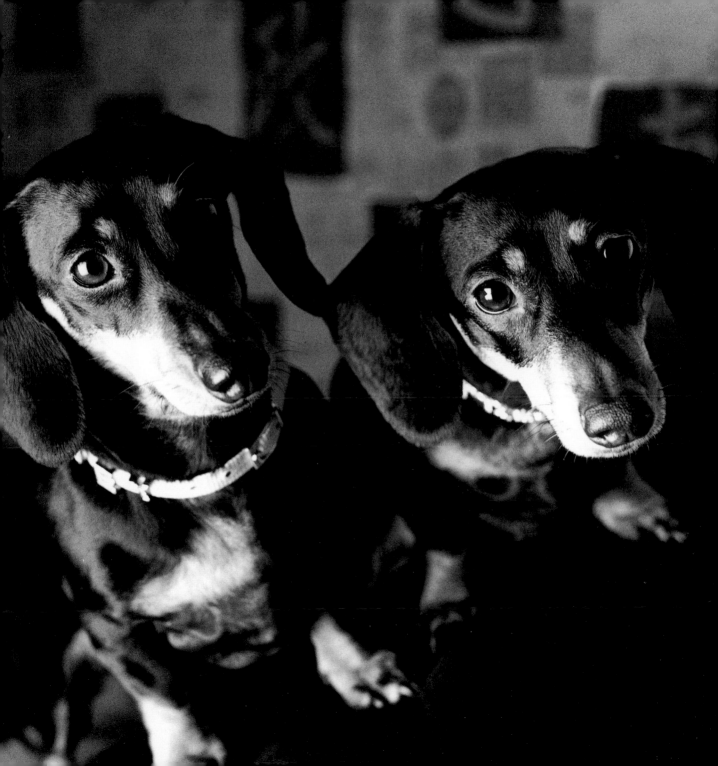

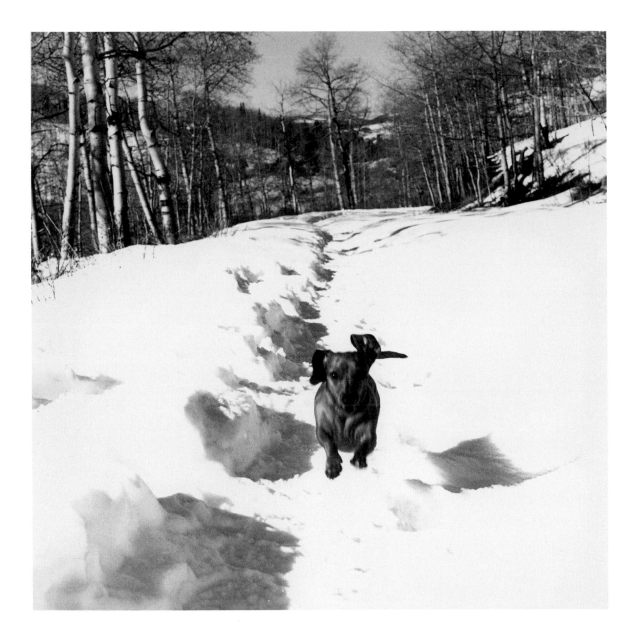

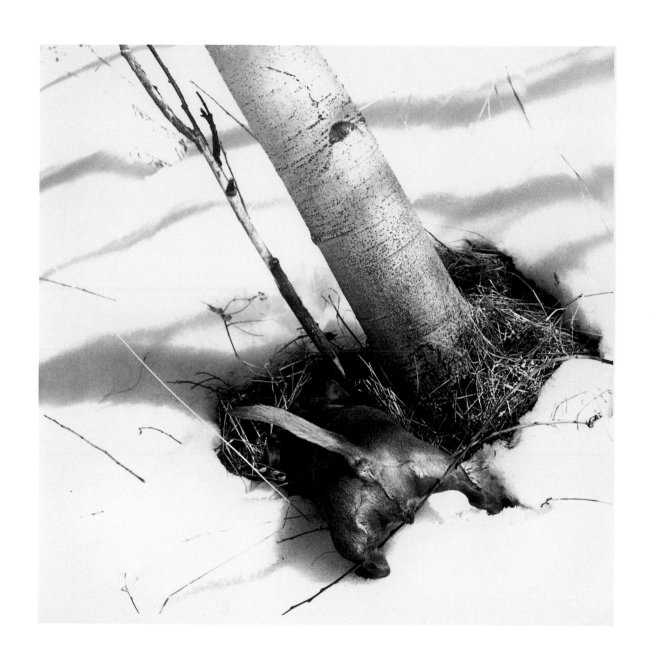

Nobody has ever measured,
not even poets,
how much the heart can hold.

—Zelda Fitzgerald

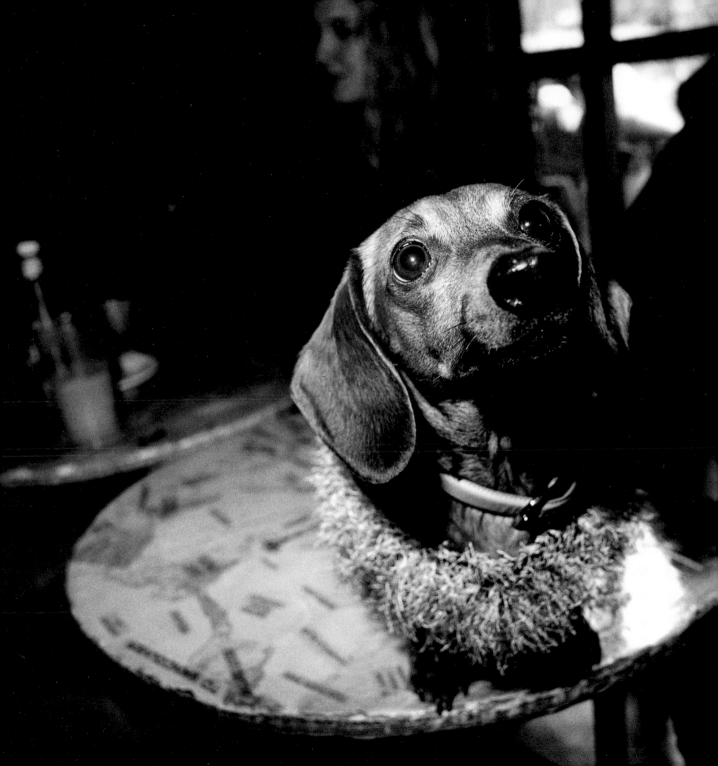

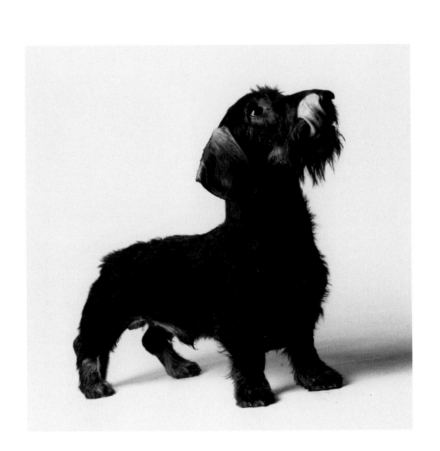

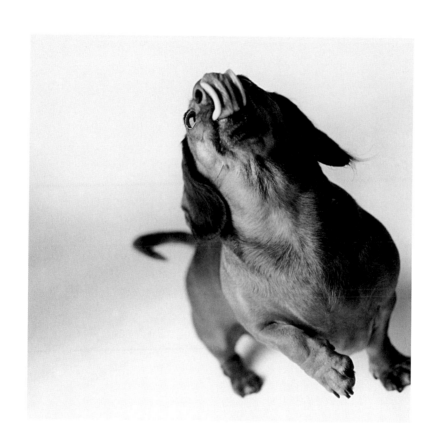

Let us be grateful to people
who make us happy, they are
the charming gardeners who
make our souls blossom.

—MARCEL PROUST

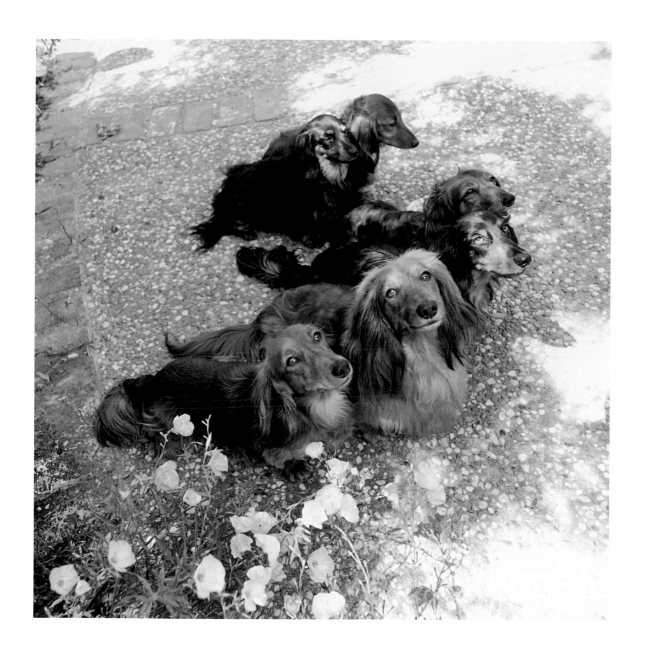

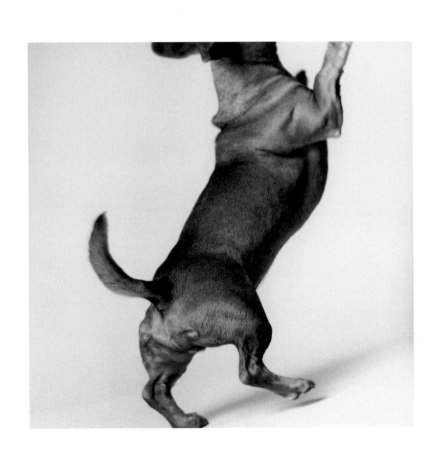

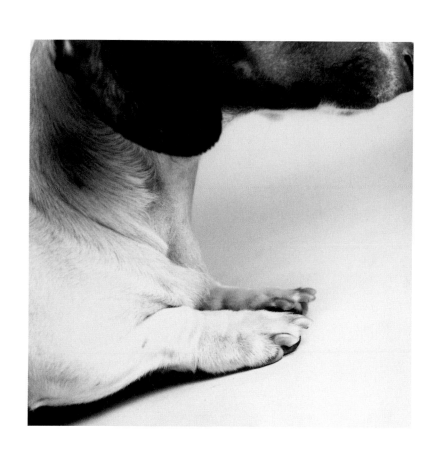

Why was this wrapper in the trash?
There's lots of lickable stuff on it.

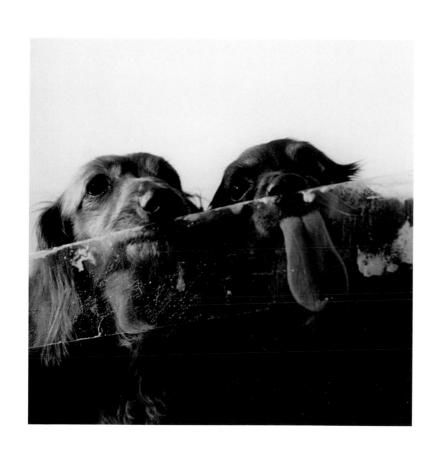

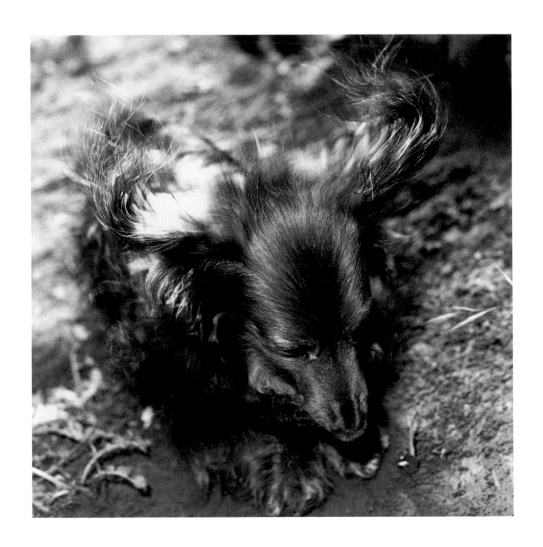

Digging!

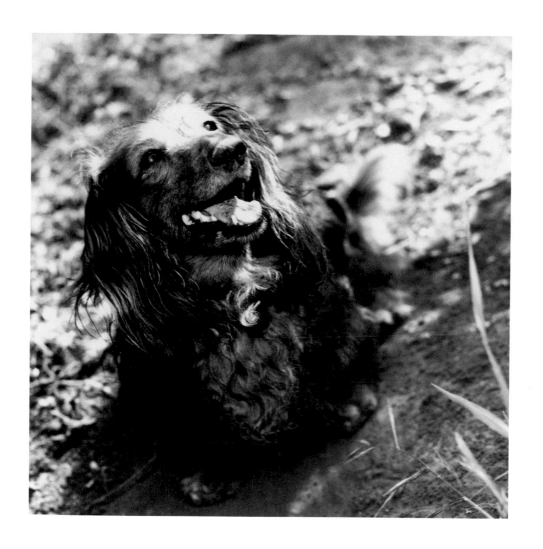

Sitting in the dirt
Even for a little while
Makes me smile.

Play ball?

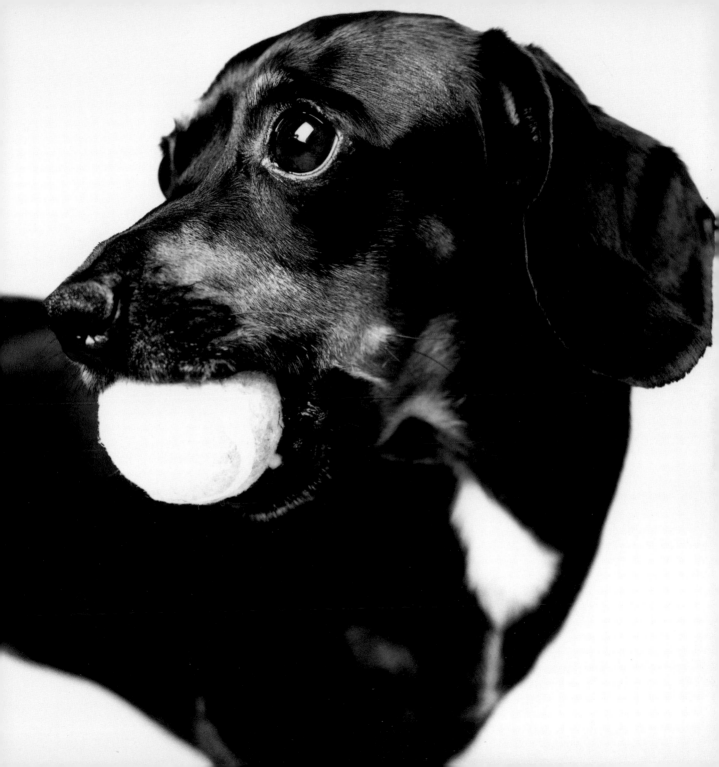

The full nose wrap.

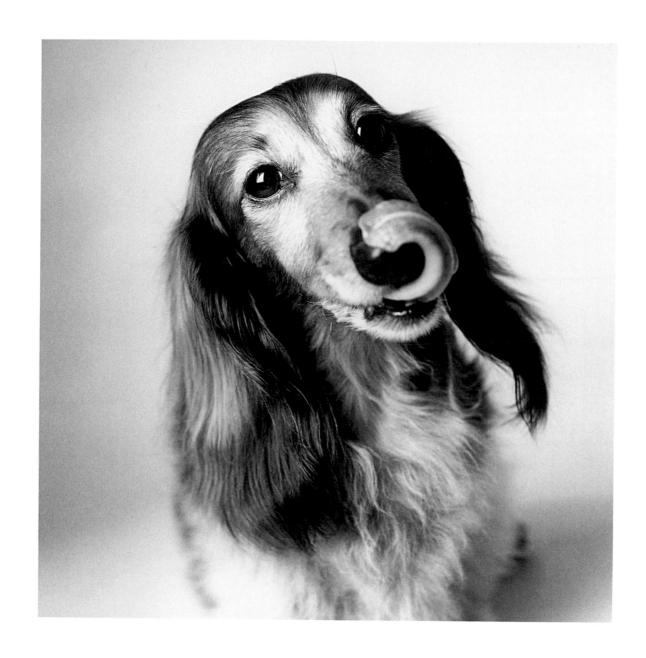

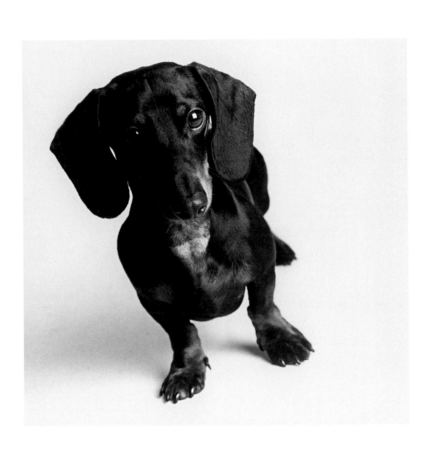

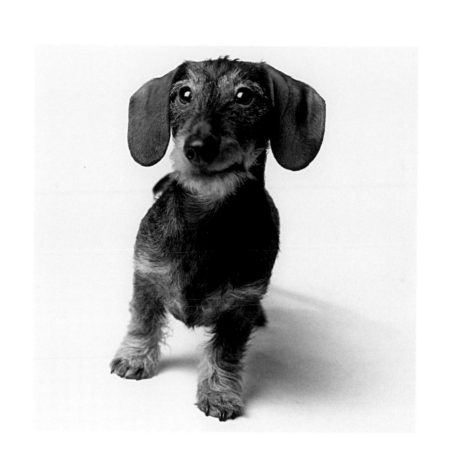

Nothing will turn a man's
home into a castle more
quickly and effectively than a
dachshund.

—QUEEN VICTORIA

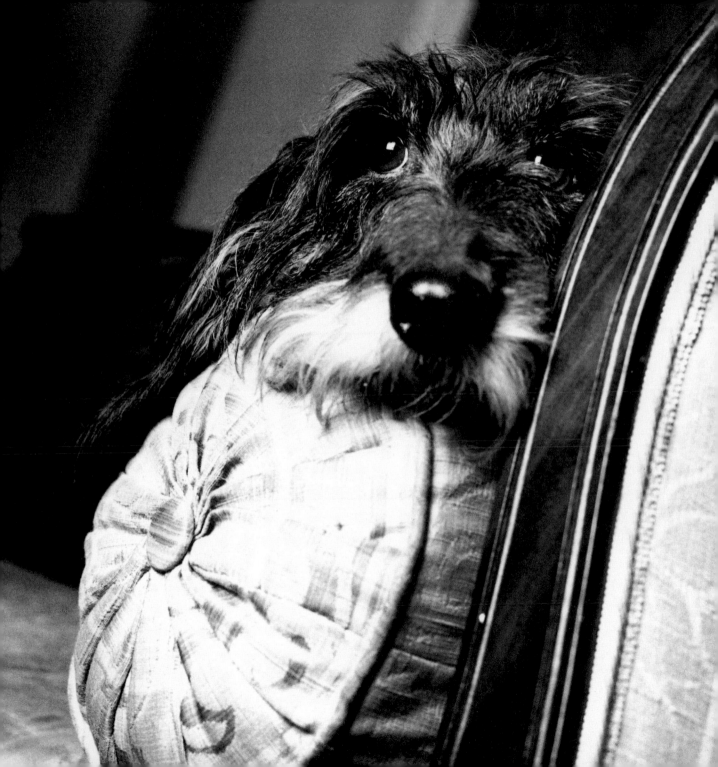

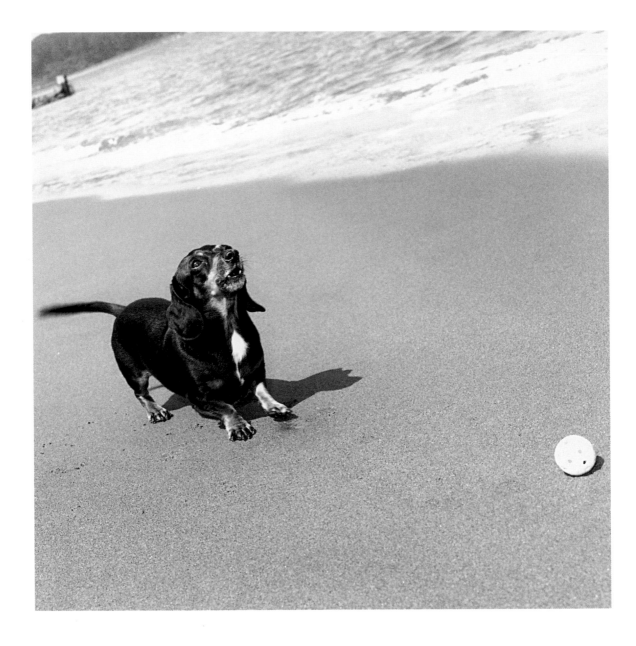

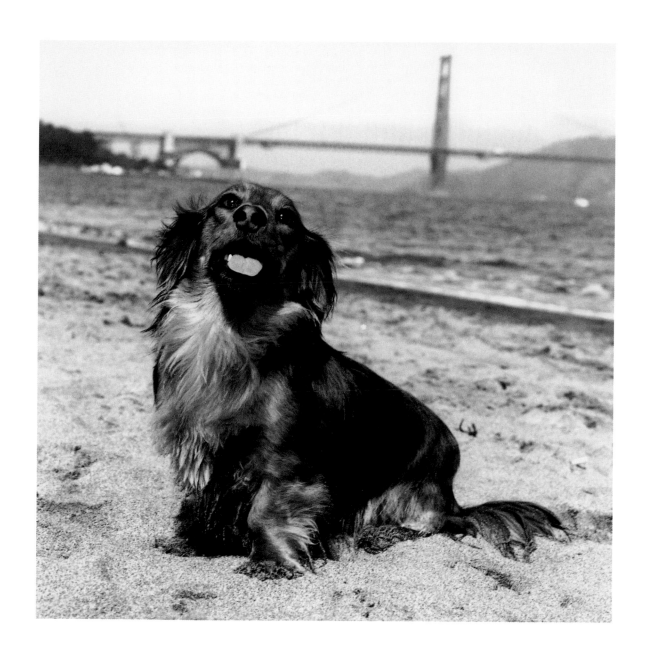

I am the boss! Don't you see?
Listen to me! Listen to Me!!!

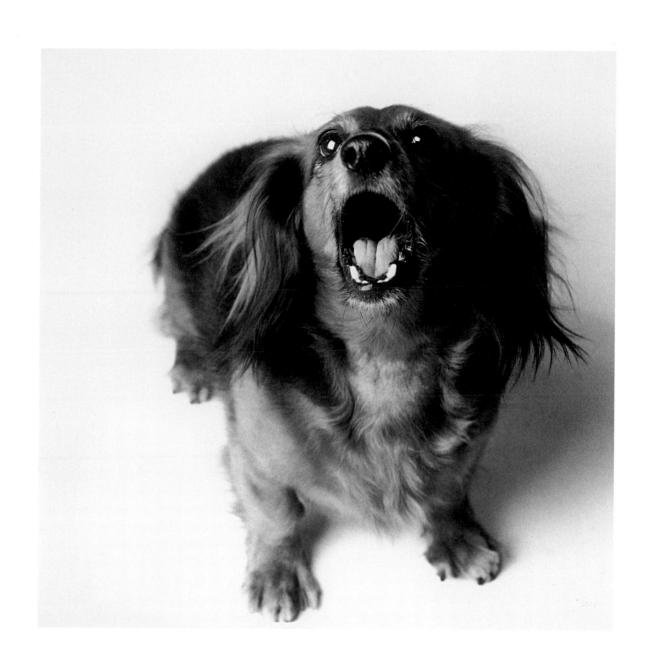

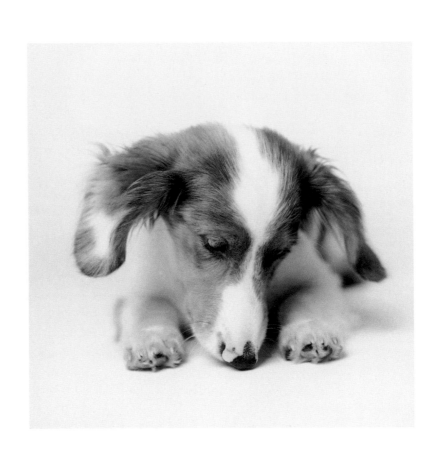

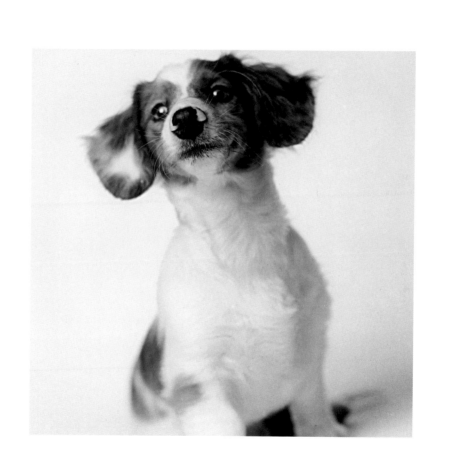

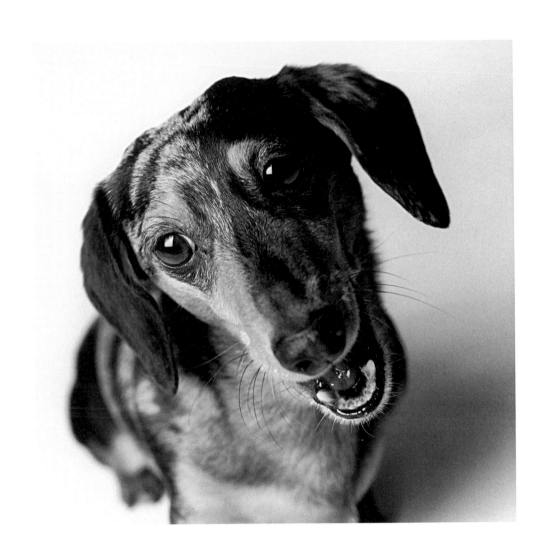

Hey there!

How's it going you two?

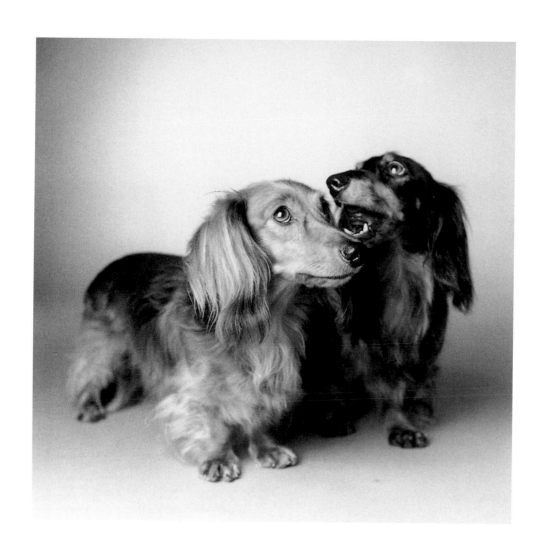

That one is such a smoothie.

I would rather train a striped
zebra to balance an Indian club
than induce a dachshund to
heed my slightest command.
—E. B. White

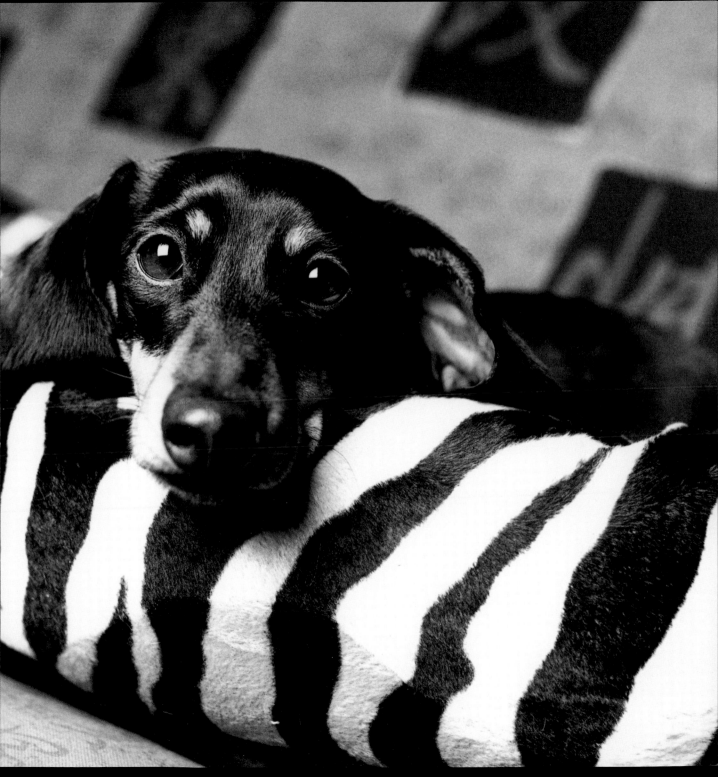

A warm spot on the floor in the sun.
Sometimes, that's all I need.

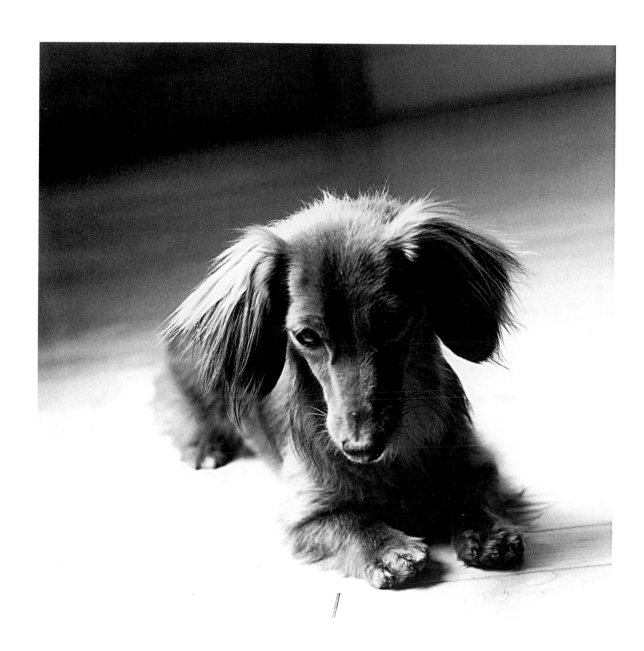

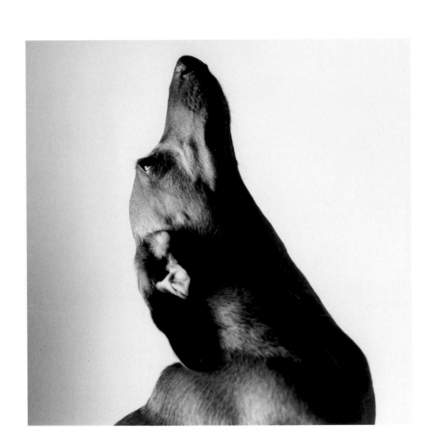

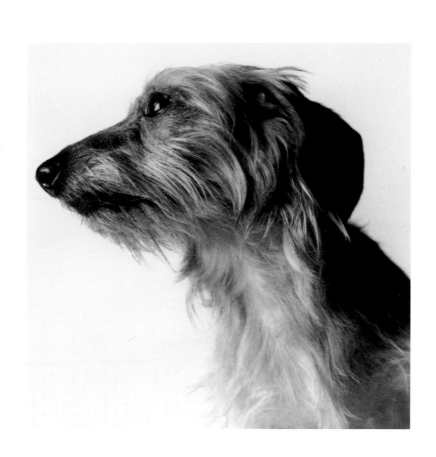

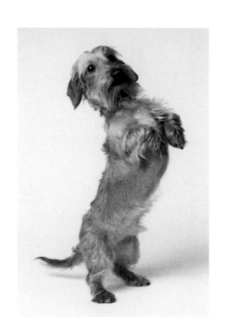
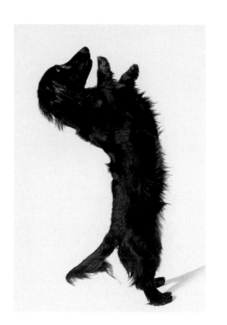

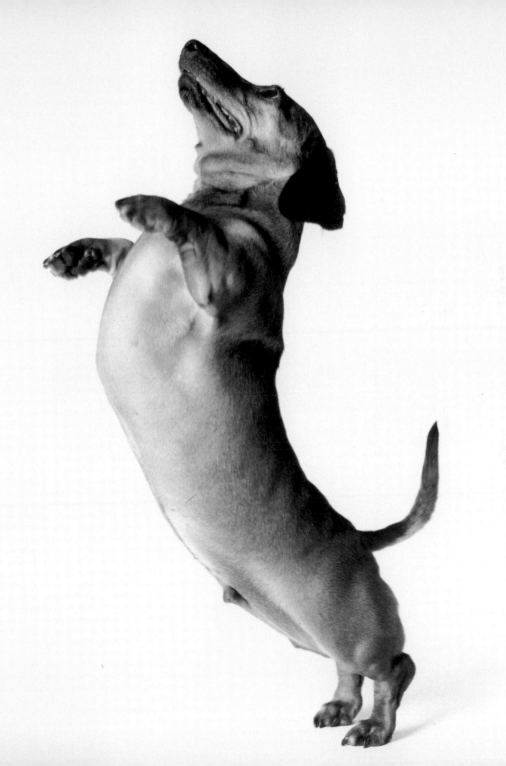

Resting those dogs on the table.

Whatever our souls are made of,
his and mine are the same.

—EMILY BRONTË

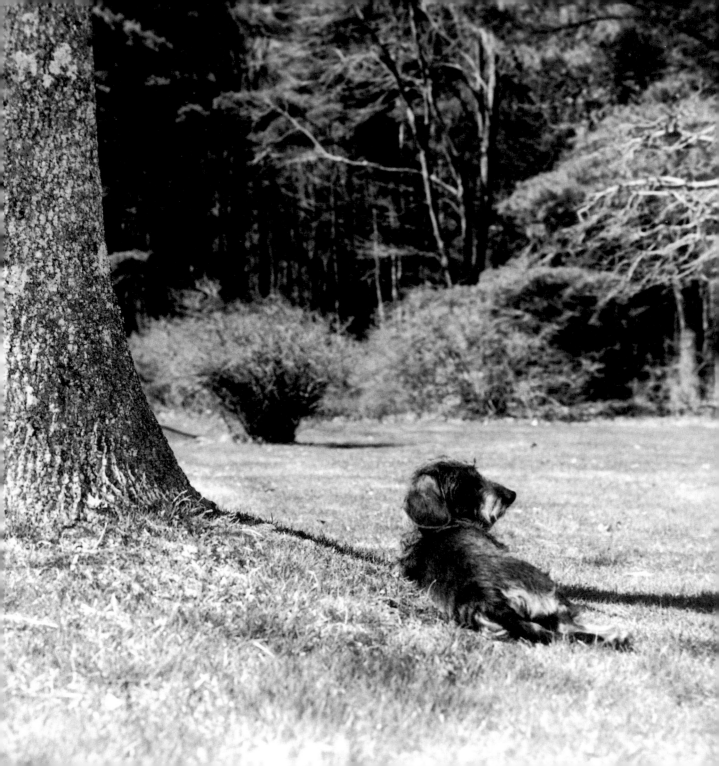

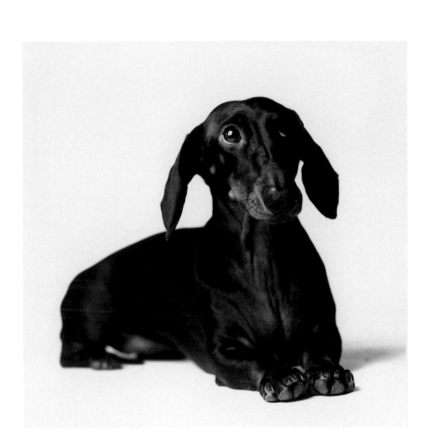

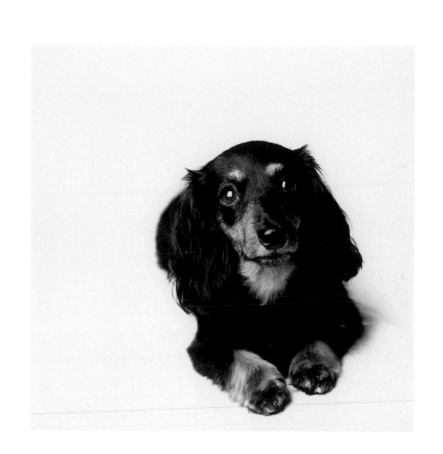

Summertime
and the living is easy.

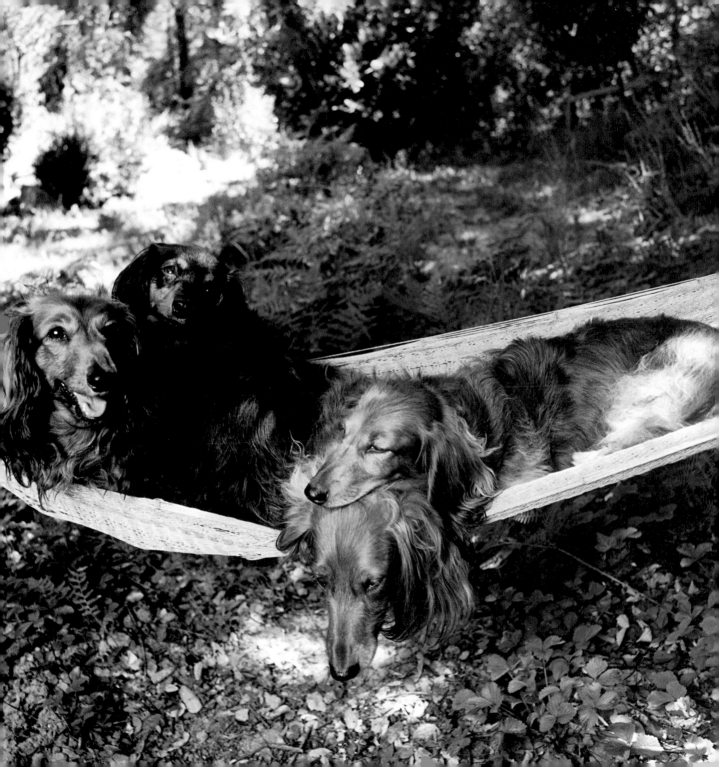

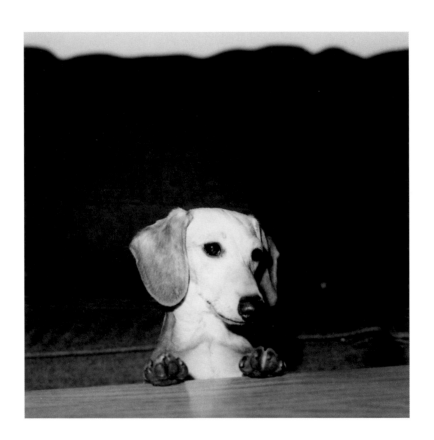

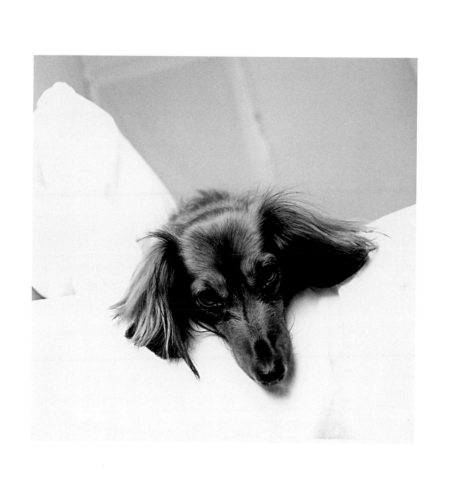

It's cold down here
and warm up there.
Could you give me a lift
onto your chair?

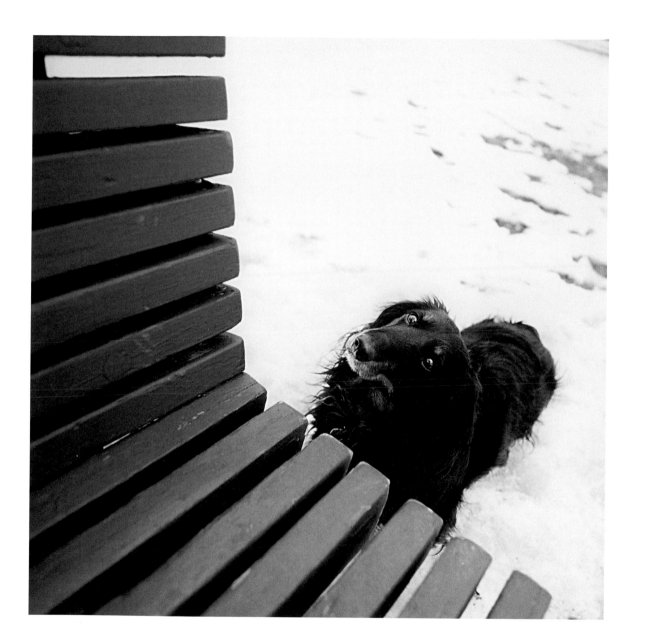

Ramp it up!

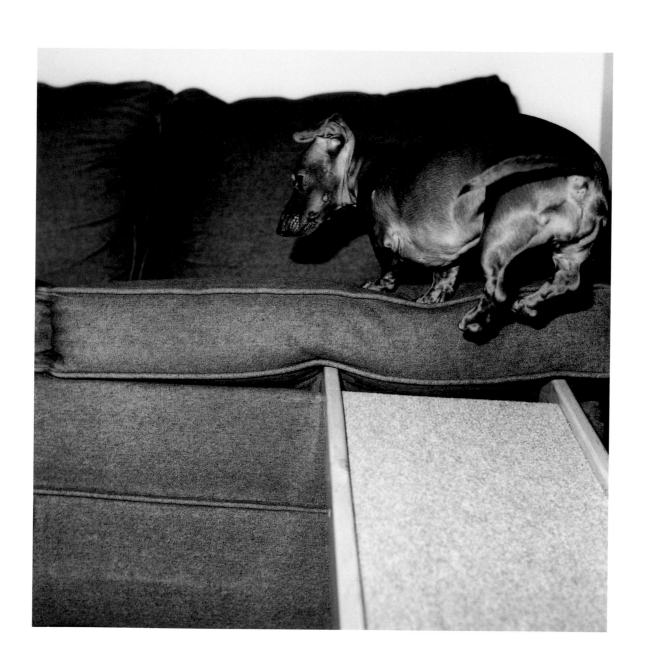

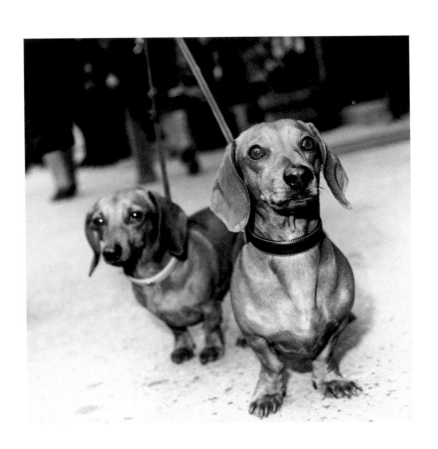

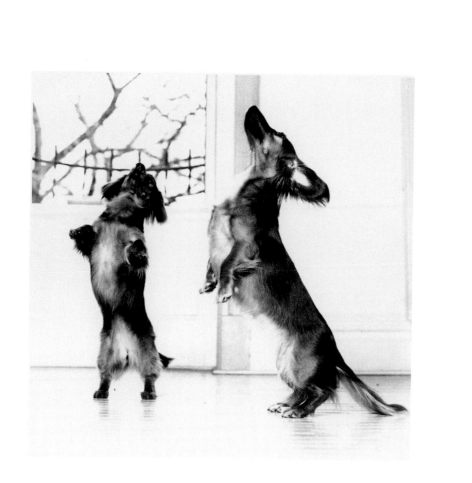

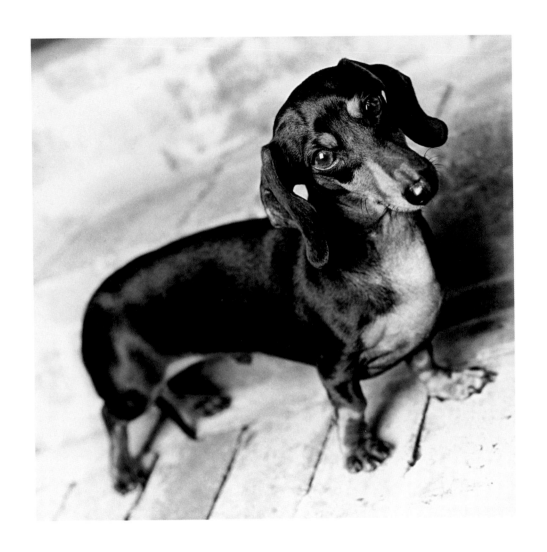

You say my nose, sir, reminds
you of a dachshund? . . .

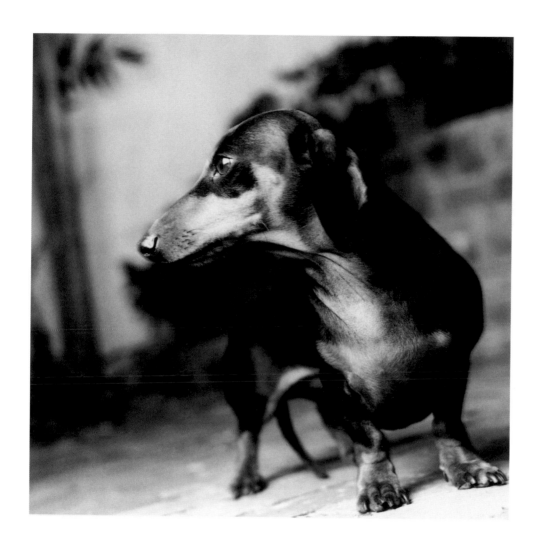

That is the first flattering remark
anyone has made of it.

—Cyrano de Bergerac

This round thing
all spiky and tough?
I will shred it to pieces!
So, please buy me more stuff!!

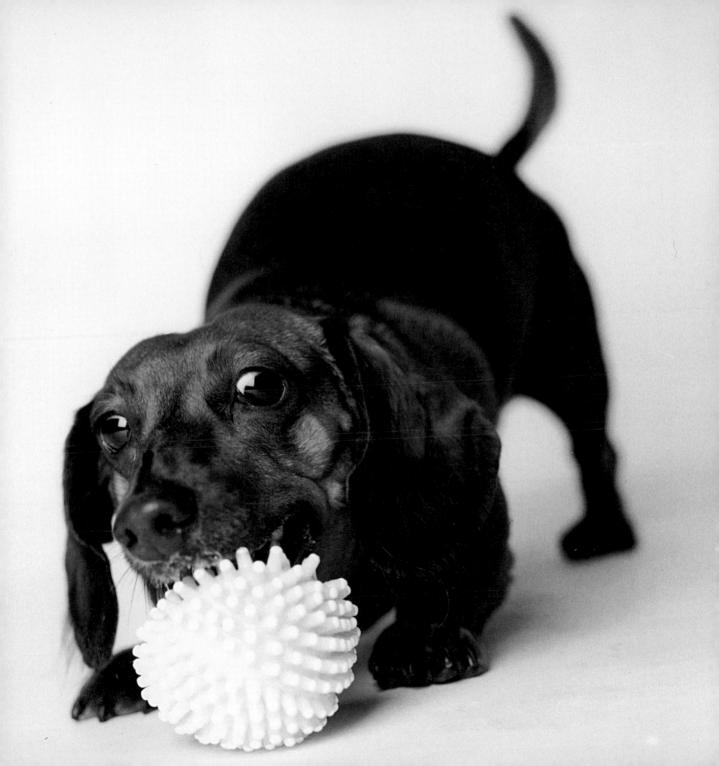

Thanks to the following Dachshunds (and their humans!) who participated in this project:

Dagmar, Zachary, Becket, Sonny, Calabaza, Remolino, Olivia, Henry, Jetta,
Charlie, Inari, Noelle, Isabel
Ellie
Waldo
Hogan, Hannah, Rune & Zeke
Boomer & Molly
Vincent
Lucia & Franklin
Nico, Ruby, Luke Skywagger, Hannah, Sidney, Little D, Joey
Bobby & Carly
Louise
Juanita
Shannon & Dexter
Daphne
Popeye, Sweet Pea, Violet & Bear
Winston, Dashiel, Sophie, Otto, Calvin, Steak, Bailey, Arrow-Kage
Romeo & Bruno
Lily & Lazza
Max
Fred
Zeppelin
Sigmund & Agnes
Patrick
Petey

If you are thinking of bringing a Dachshund into your life, you can read about them on various websites dedicated to these dogs, to make sure that a Dachshund is a good fit for your lifestyle. Below are some sites you may want to visit:

Longdogs Canine Rescue (Northern California Dachshund Rescue)
www.willeyfarm.com/Longdogs

Dachshund Rescue Web Page
www.drwp.net

Dachshund Rescue of North America
www.drna.org

Almost Home Dachshund Rescue Society
www.almosthomerescue.org